Color By Number Adult Coloring Book of Winter

This Winter Coloring Book belongs to:

Copyright © 2019 Winter Coloring Books

1. Black
2. Green
3. Blue
4. Brown
5. Purple
6. Light Blue
7. Light Green
8. Orange
9. Dark Red
10. Pink
11. Red
12. Dark Green
13. Gold
14. Violet
15. Yellow

1. Red
2. Green
3. Blue
4. Brown
5. Purple
6. Light Blue
7. Light Green
8. Orange
9. Dark Red
10. Pink
11. Black
12. Dark Green
13. Gold
14. Violet
15. Yellow

1. Red
2. Green
3. Blue
4. Brown
5. Purple
6. Light Blue
7. Light Green
8. Orange
9. Dark Red
10. Pink
11. Black
12. Dark Green
13. Gold
14. Violet
15. Yellow

1. Red
2. Green
3. Blue
4. Brown
5. Purple
6. Light Blue
7. Light Green
8. Orange
9. Dark Red
10. Pink
11. Black
12. Dark Green
13. Gold
14. Violet
15. Yellow

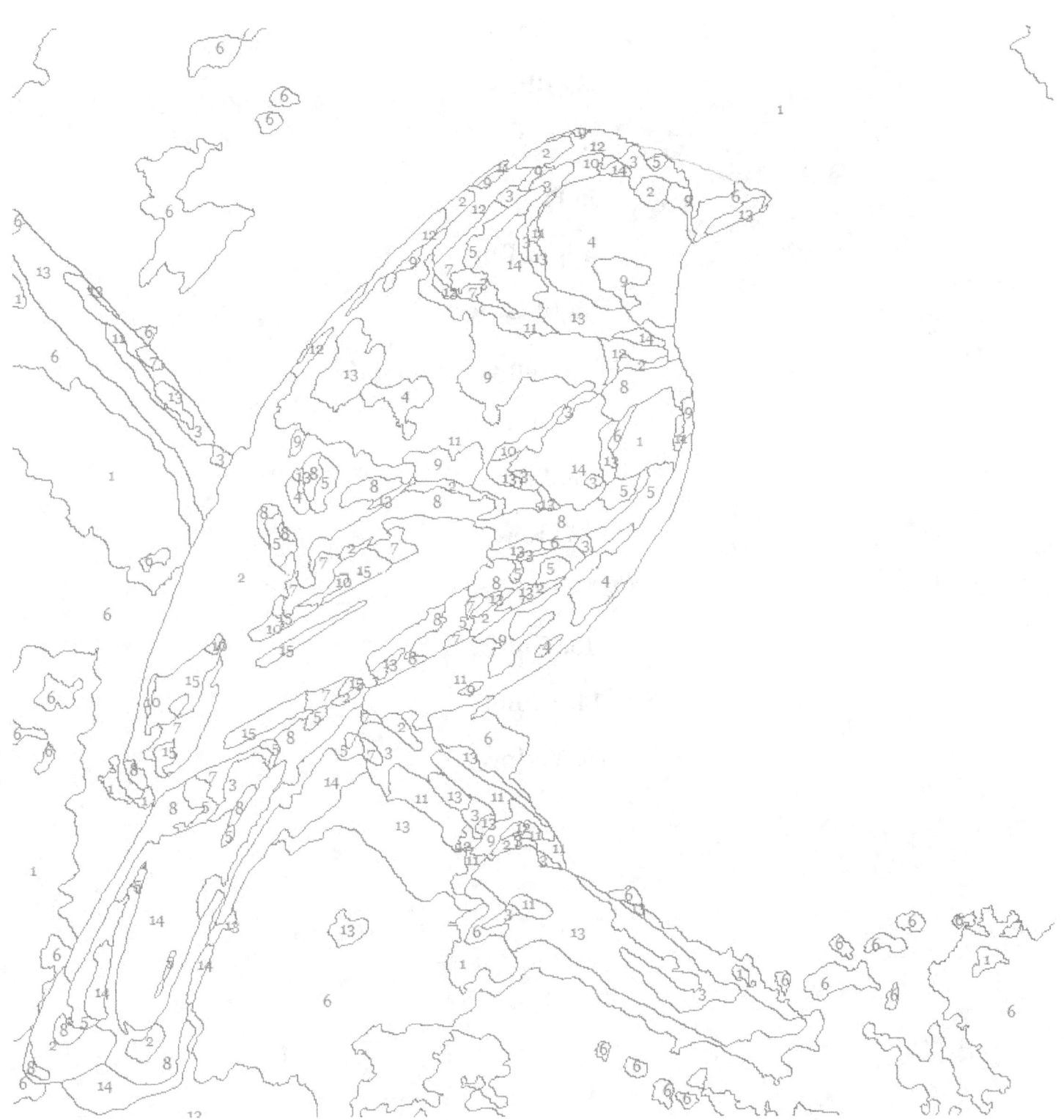

1. Black
2. Green
3. Blue
4. Brown
5. Purple
6. Light Blue
7. Light Green
8. Orange
9. Dark Red
10. Pink
11. Red
12. Dark Green
13. Gold
14. Violet
15. Yellow

1. Black
2. Green
3. Blue
4. Brown
5. Purple
6. Light Blue
7. Light Green
8. Orange
9. Dark Red
10. Pink
11. Red
12. Dark Green
13. Gold
14. Violet
15. Yellow

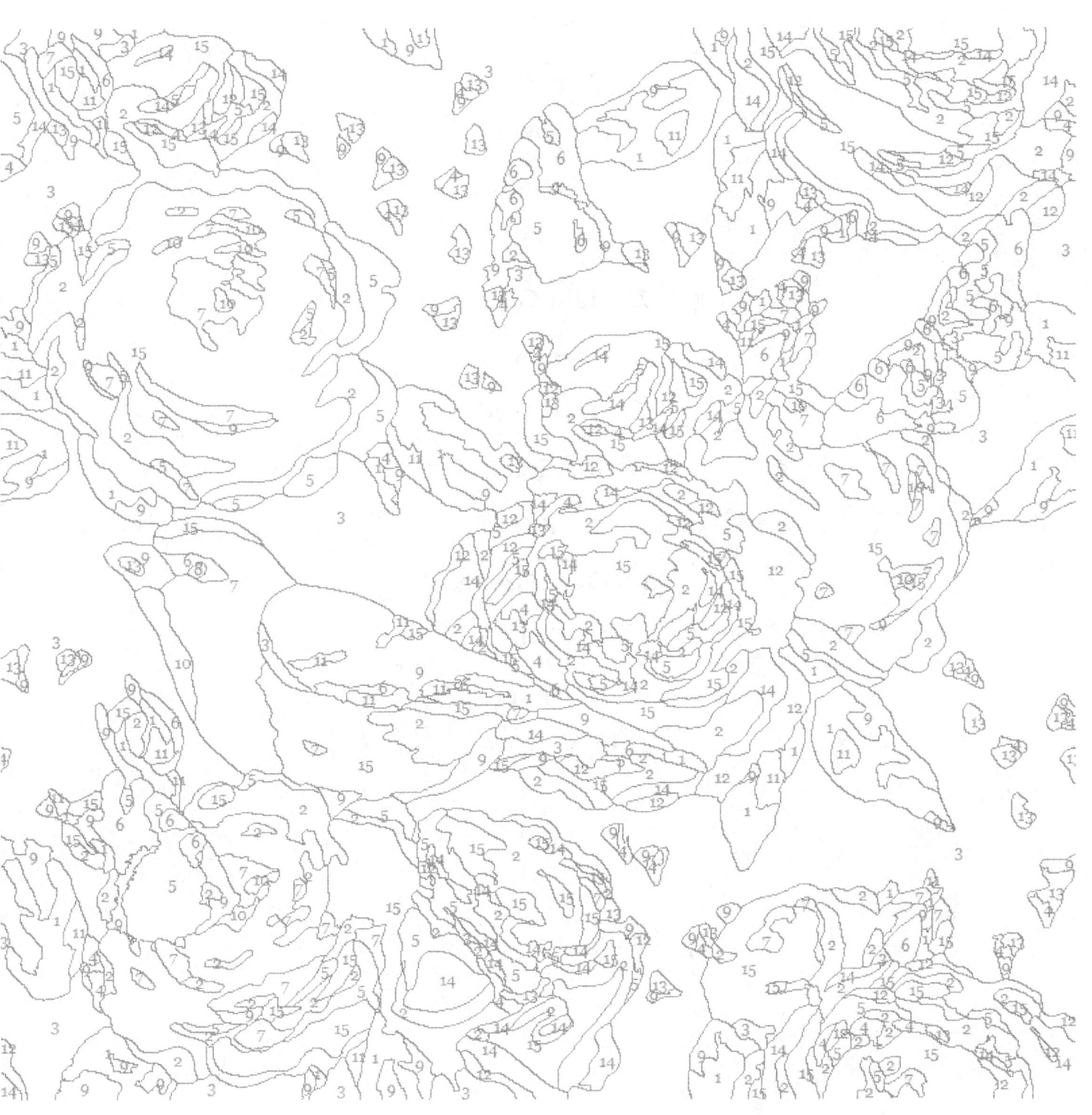

1. Black
2. Green
3. Blue
4. Brown
5. Purple
6. Light Blue
7. Light Green
8. Orange
9. Dark Red
10. Pink
11. Red
12. Dark Green
13. Gold
14. Violet
15. Yellow

1. Black
2. Green
3. Blue
4. Brown
5. Purple
6. Light Blue
7. Light Green
8. Orange
9. Dark Red
10. Pink
11. Red
12. Dark Green
13. Gold
14. Violet
15. Yellow

1. Black
2. Green
3. Blue
4. Brown
5. Purple
6. Light Blue
7. Light Green
8. Orange
9. Dark Red
10. Pink
11. Red
12. Dark Green
13. Gold
14. Violet
15. Yellow

1. Black
2. Green
3. Blue
4. Brown
5. Purple
6. Light Blue
7. Light Green
8. Orange
9. Dark Red
10. Pink
11. Red
12. Dark Green
13. Gold
14. Violet
15. Yellow

16. Red

17. Green

18. Blue

19. Brown

20. Purple

21. Light Blue

22. Light Green

23. Orange

24. Dark Red

25. Pink

26. Black

27. Dark Green

28. Gold

29. Violet

30. Yellow

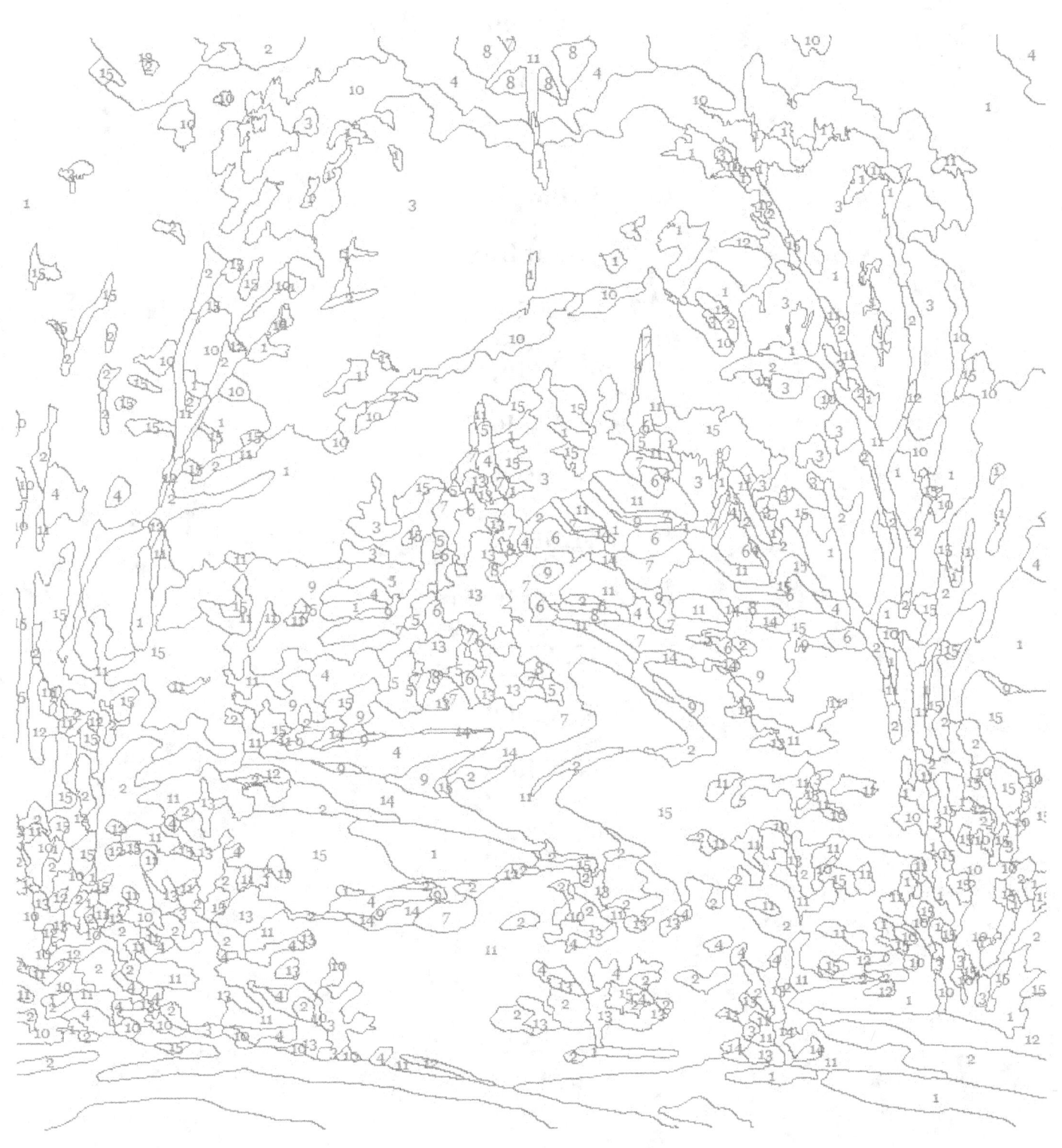

1. Red
2. Green
3. Blue
4. Brown
5. Purple
6. Light Blue
7. Light Green
8. Orange
9. Dark Red
10. Pink
11. Black
12. Dark Green
13. Gold
14. Violet
15. Yellow

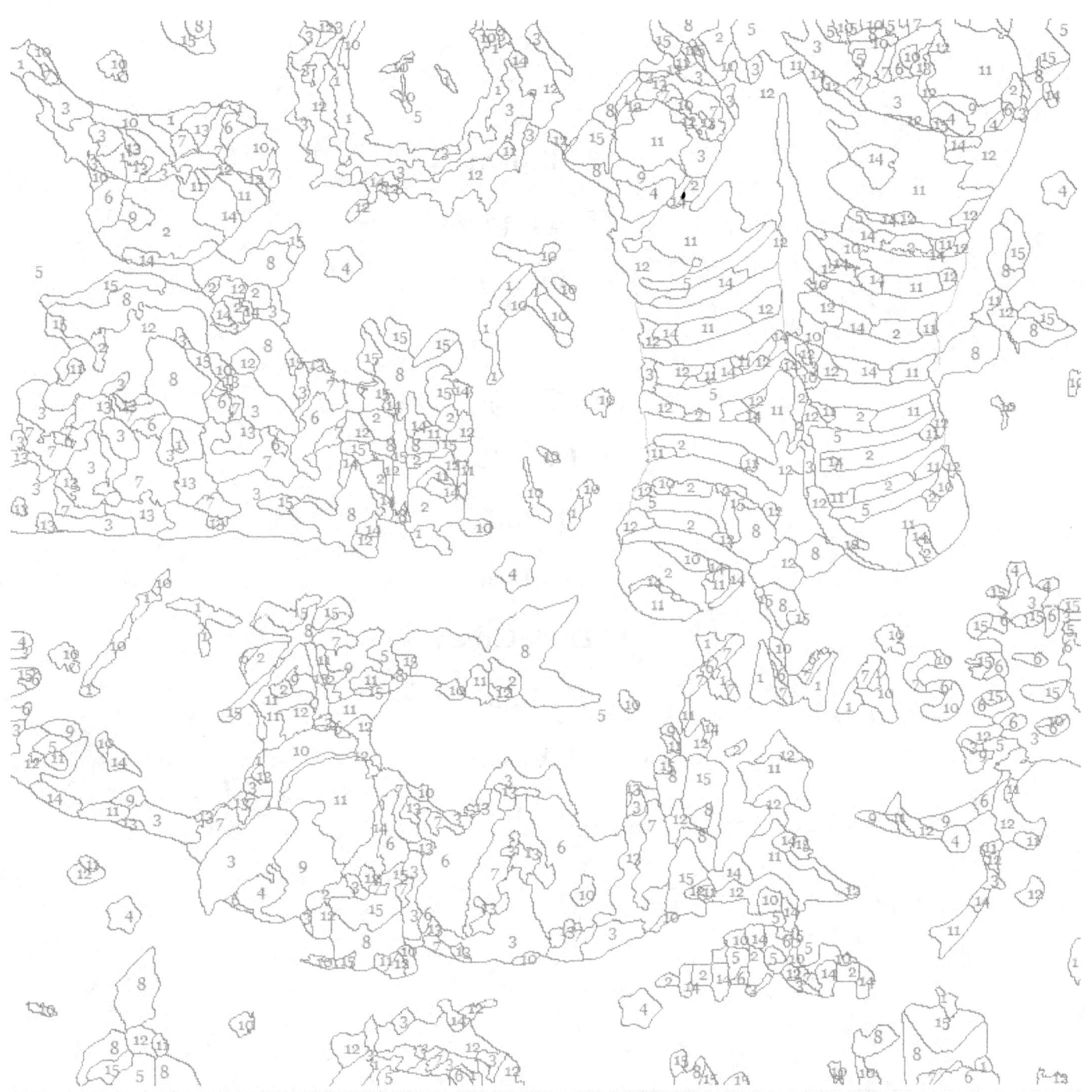

1. Red
2. Green
3. Blue
4. Brown
5. Purple
6. Light Blue
7. Light Green
8. Orange
9. Dark Red
10. Pink
11. Black
12. Dark Green
13. Gold
14. Violet
15. Yellow

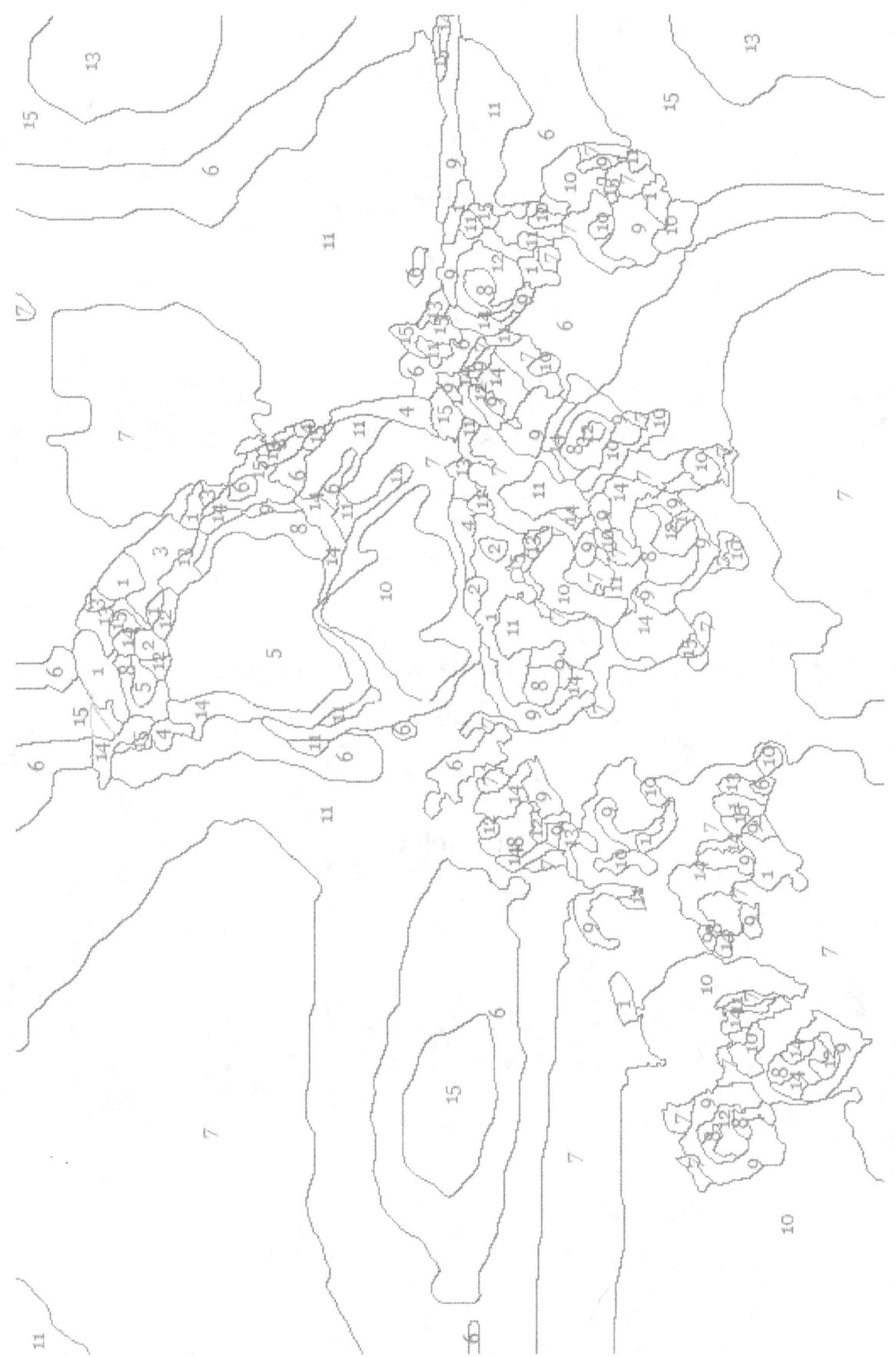

1. Red
2. Green
3. Blue
4. Brown
5. Purple
6. Light Blue
7. Light Green
8. Orange
9. Dark Red
10. Pink
11. Black
12. Dark Green
13. Gold
14. Violet
15. Yellow

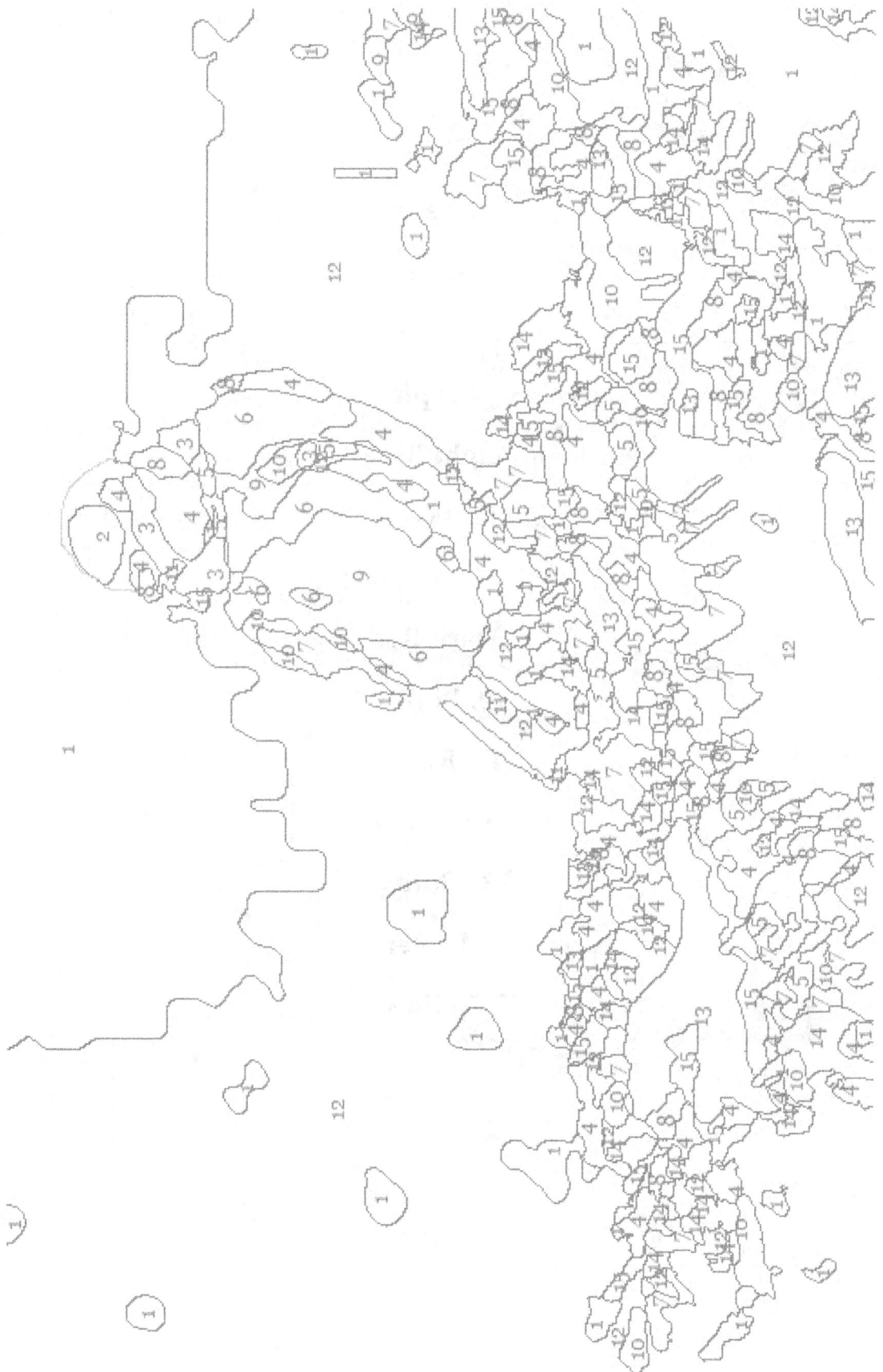

1. Black
2. Green
3. Blue
4. Brown
5. Purple
6. Light Blue
7. Light Green
8. Orange
9. Dark Red
10. Pink
11. Red
12. Dark Green
13. Gold
14. Violet
15. Yellow

1. Black
2. Green
3. Blue
4. Brown
5. Purple
6. Light Blue
7. Light Green
8. Orange
9. Dark Red
10. Pink
11. Red
12. Dark Green
13. Gold
14. Violet
15. Yellow

1. Black
2. Green
3. Blue
4. Brown
5. Purple
6. Light Blue
7. Light Green
8. Orange
9. Dark Red
10. Pink
11. Red
12. Dark Green
13. Gold
14. Violet
15. Yellow

1. Red
2. Green
3. Blue
4. Brown
5. Purple
6. Light Blue
7. Light Green
8. Orange
9. Dark Red
10. Pink
11. Black
12. Dark Green
13. Gold
14. Violet
15. Yellow

1. Red
2. Green
3. Blue
4. Brown
5. Purple
6. Light Blue
7. Light Green
8. Orange
9. Dark Red
10. Pink
11. Black
12. Dark Green
13. Gold
14. Violet
15. Yellow

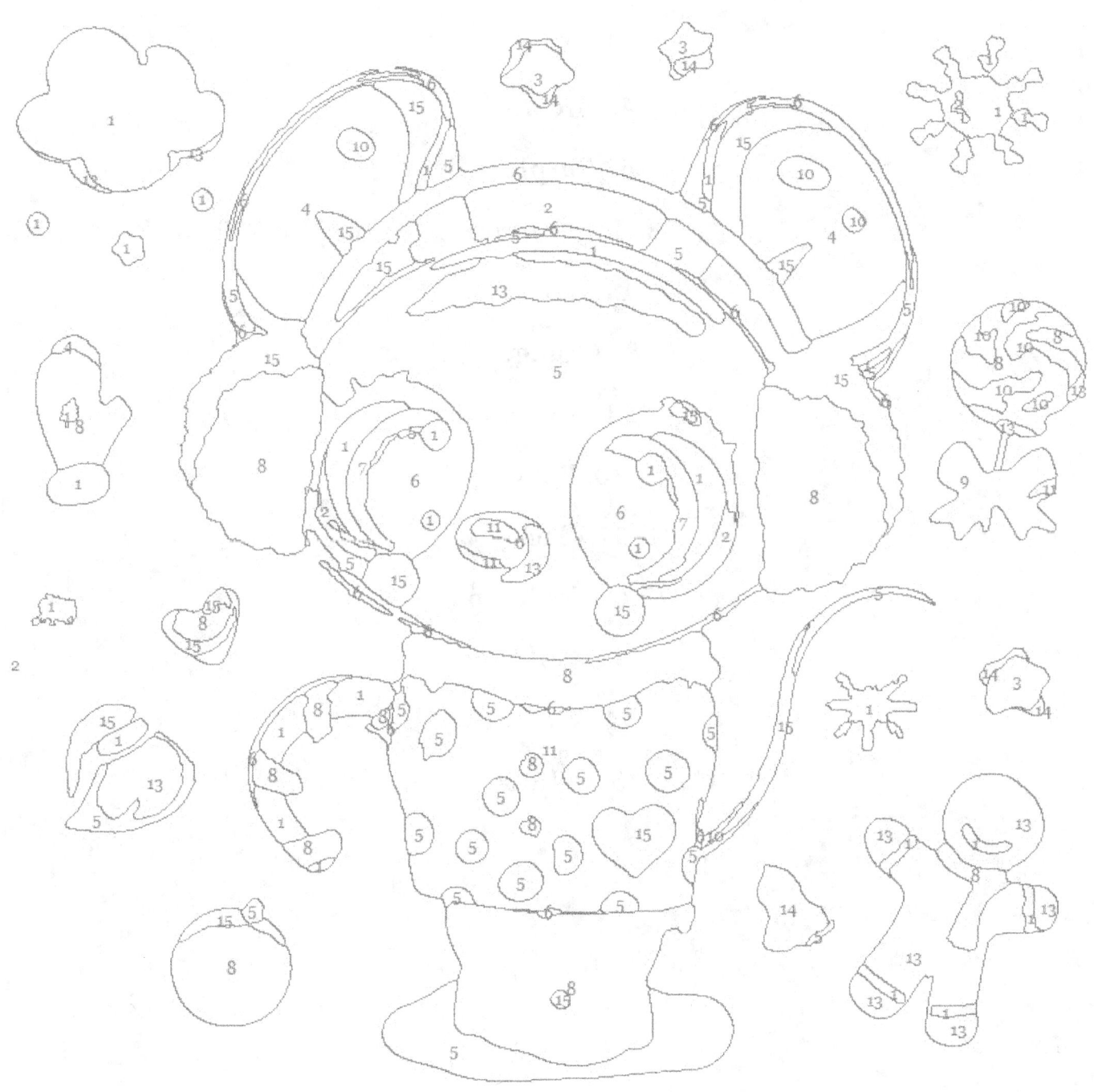

1. Red
2. Green
3. Blue
4. Brown
5. Purple
6. Light Blue
7. Light Green
8. Orange
9. Dark Red
10. Pink
11. Black
12. Dark Green
13. Gold
14. Violet
15. Yellow

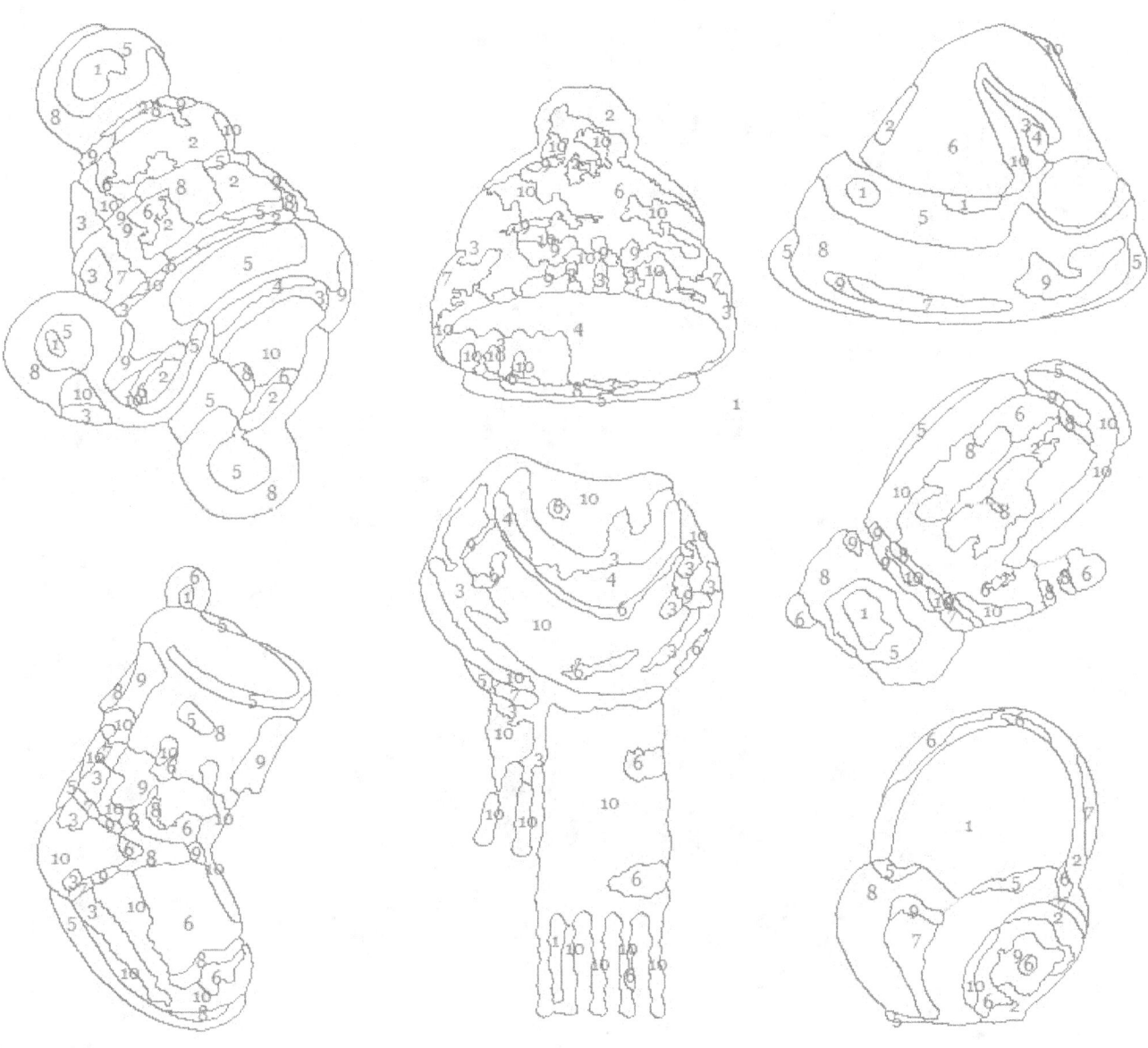

3 bonus coloring page

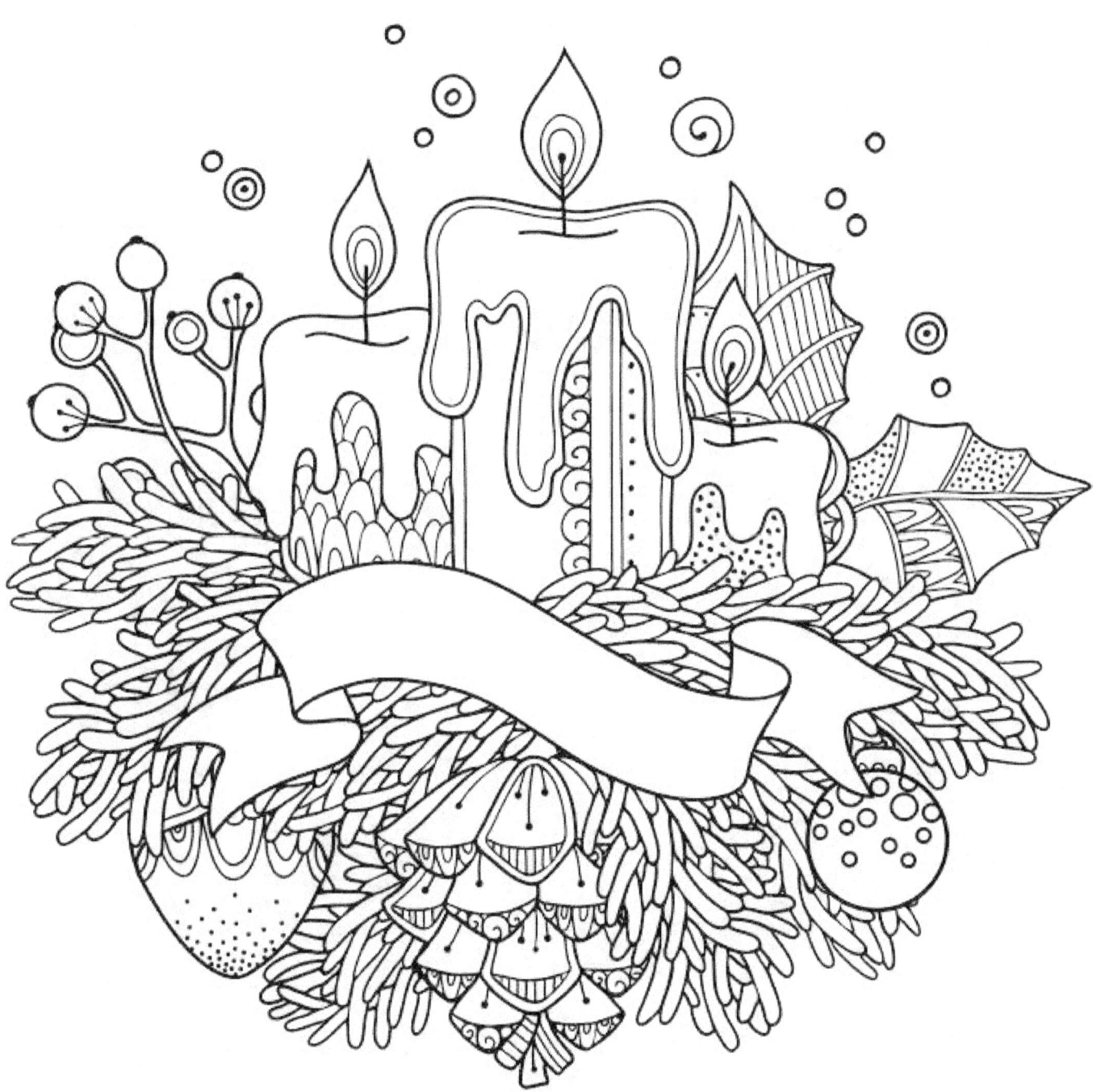

www.ingramcontent.com/pod-product-compliance
Lightning Source LLC
Chambersburg PA
CBHW080911220526
45466CB00011BA/3550

9781692251130